Sculpturing

by
Domenico Mazzone

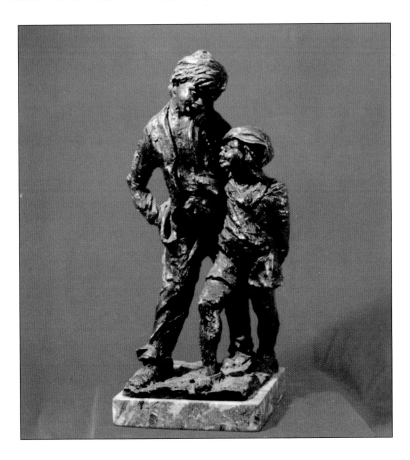

Walter Foster Publishing, Inc.
23062 La Cadena Drive,
Laguna Hills, California 92653

Contents

Acknowledgements

I would like to thank Walter Foster Publishing for giving me the opportunity to share my experience with all of you. I would also like to thank my son, Dr. Peter Mazzone, for translating the text. I hope that this book will inspire every one of you.

Foreword

The beginning of a career is always full of unknowns and surprises. But, if your chosen career happens to be art—particularly sculpture—you need a special kind of passion and an almost unlimited determination. Indeed, because of the fear of failure, modeling the first piece of sculpture can be an anxiety-provoking experience for anyone.

My advice to those wishing to succeed in the world of sculpture is to first master the art of persistence. In other words, always keep trying—never give up! Moreover, try not to become discouraged; most of the professional sculptors I know (including myself) are rarely satisfied with their completed works.

The purpose of this book is to encourage those who are interested in sculpture to pursue that interest. I will share with you some of the secrets and shortcuts I have learned throughout my career. I will also demonstrate a variety of sculpting methods. Together, we will sculpt in the traditional manner using common materials, such as terra-cotta, clay, wax, and plasteline. We will begin by modeling simple figurines and then work our way up to more sophisticated sculptures. In addition, we will explore some of the various approaches employed in sculpture, including the original method (page 35) and the semi-hollow method (page 50). We will also spend a bit of time learning how to reproduce our statues by utilizing the three-piece stampo method (pages 42-48). Finally, we will examine the most simple staining methods available for completed works: the bronze and color patinas.

Throughout this book, I have indicated an approximate size for each of the projects demonstrated. These sizes are for reference only; you can make your sculptures any size you wish. When using certain methods, such as the semi-hollow terra-cotta method, however, keep in mind that the subject must be fairly small.

Obviously, there is not enough space in this volume to thoroughly cover all of the techniques and media that can be used for sculpture. Therefore, my approach has been to limit the discussion to modeling sculpture (as opposed to carving sculpture) and to highlight the basic methods needed to get started. It is my hope that once you have mastered these fundamental skills, you will explore the many possibilities of sculpture on your own. To the extent that this book inspires the individual's curiosity, its goal will have been achieved.

—Domenico Mazzone

The Modeler and the Carver

A student once asked me, "What is the difference between a sculptor who carves and a sculptor who models?" Perhaps without realizing it, the student had raised a fundamental question that, in all my years of teaching, had never been raised before. The answer I gave her is of such basic importance (and so often overlooked) that I am now compelled to repeat it to anyone considering sculpture as a pastime, hobby, or career.

There are two types of sculptors, and each uses a very different technique. "Modeling" sculptors create works of art by adding and molding soft materials, such as clay, wax, or plasteline (a non-hardening modeling clay made of clay mixed with various chemicals and oils), into specific shapes and then transforming the finished products into a "hard" medium (usually plaster of paris) using various processes—for example, the "lost-mold" method (described on pages 33 and 49) or the "three-piece stampo" method (demonstrated on pages 42-48). In contrast, "carving" sculptors use a reversal of this process; they create a masterpiece by removing, or chiseling, material from a shapeless block of wood or stone (usually marble or granite). Another important distinction between the two types is the manner in which they begin their respective works. Modelers commonly start by intensely studying their subject. They usually spend quite a bit of time sketching and drawing the subject until they are completely comfortable with it; they may even have people pose for them or use references, such as photographs, while working. Many carvers, on the other hand, do not normally practice or even study their subject ahead of time, nor do they use models for their work. Instead, they usually employ a crude-cut method of sculpture wherein granite or marble is "cut" without having in mind a specific end result.

The distinctions noted above are not meant to imply that one type of sculptor is superior to the other or that the two types are mutually exclusive. Instead, the distinctions are simply intended to convey that the two types of sculptor employ different techniques to reach the same goal. There are many sculptors who have never carved a piece of marble, and there are many who have never modeled clay. Nevertheless, both types—as well as those who work with both methods—have enjoyed success.

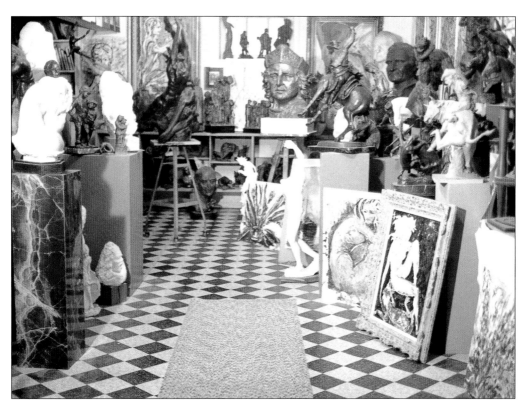

The Sculptor's Studio

Unlike painting, which can be easily done almost any place, sculpting requires a specific workplace or studio. This is because sculptors need substantial space in which to make use of their numerous tools, armatures, plaster, clay, plasteline, jars of paint, and so forth. Also, the nature of a sculptor's work promotes dust and disorder. Thus, although the designated workplace need not be charming or elegant, it is absolutely necessary.

The figure above shows the one corner of my studio that I use for a gallery. I chose not to show the other portion of the studio—the actual workplace—because disorder, confusion, and chaos reign supreme there. When one has several projects in various stages of completion, this is a natural occurance—no matter how orderly one tries to be.

Sculpting Materials

There are many different materials, both soft and hard, that can be used for sculpture. The principal soft materials include plasteline, clay, wax, plaster (many sculptors model directly with plaster), and terra-cotta (a versatile soft material that hardens after baking). The principal hard materials include marble, bronze, granite, and metal.

In addition to these "traditional" media, there are many other materials which can be used for sculpture, including ceramic, bisquit (bisquit—or bisque—is a mass of earth clay that has been fired or baked but not glazed), alabaster, wood, ivory, papier-maché, fiberglass, resin, acrylic, silver, gold and other metals, and precious stones. Some of these materials are rather difficult to work with and require quite a bit of experience.

I recommend that beginning sculptors start with wax, clay, plasteline, or terra-cotta. For this reason, the demonstrations in this book are restricted to these four materials. These products are available in virtually any art store and are relatively inexpensive; that is, the price rarely exceeds one dollar per pound of material.

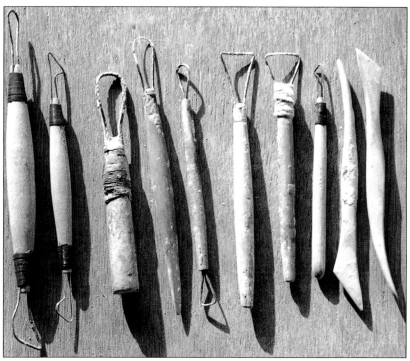
figure 1

Sculpting Tools

Sculpting tools can be broadly subdivided into two distinct groups: those used for soft materials, such as clay, wax, and plasteline, and those used for the harder materials, such as plaster and soft marble. Figure 1 shows a small group of wire-end tools and wood blade tools that are commonly used for soft media. The wire-end tools are ideal for gouging and carving clay but may also be employed in the working of other soft materials. The wood blade tools are good for carving, slicing, molding, smoothing, and so forth.

These tools are available in most art stores, but you will not need to purchase all of them to begin. The following list is sufficient to get you started:

1) Pointed wooden spatula

2) Flat wooden spatula

3) Toothed wooden spatula

4) Metal spatula with a rounded head

5) Small metal spatula

6) Medium-sized metal spatula

7) Small knife for working with plaster

8) Mallet

Armatures

An armature is a structure used to support a sculpture and allow it to stand on its own. Armatures are normally made of wood surrounded by thin metal wire. The wire provides a base, or skeleton, to which the clay or plasteline can adhere.

These days, it is not necessary to make armatures from scratch as it was when I first started sculpting. Virtually every well-stocked art store offers a vast assortment of reasonably priced armatures for portraits, full figurines, animals, and so forth. When buying a commercially made armature, it is best to shop around and pick out a solid, well-made structure designed especially for the specific subject matter.

Nevertheless, it is a good idea to learn how to make an armature for special projects or those times when a commercial figure is not available. The instructions on pages 10 and 11 explain how to make a portrait armature.

Sculpture Stands and Platforms

Before beginning, you will need to purchase a platform and work station stand. Platforms and stands come in different shapes and styles, so several differences should be noted. The platforms shown in figures 1, 2, and 3 on the opposite page are simply flat wooden boards of variable size. These provide a base on which sculptures can be erected. They are sufficient for many purposes but may be a bit awkward because they are not easily rotated. In contrast, the stands illustrated in figures 4 and 5 consist of a platform mounted to a rotating metal cylinder (figure 5 is also height-adjustable). These stands are recommended because they allow you to rotate the piece for easy access; the height-adjustable stand provides optimal working conditions.

Regardless of which type you use, a stand is an absolute necessity for sculpting, and you should check your local art stores for one that suits your needs before beginning your project.

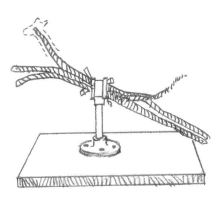

figure 1 (animal armature)

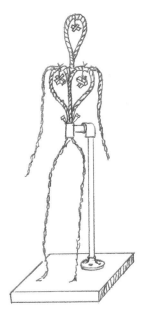

figure 2 (full-figure armature)

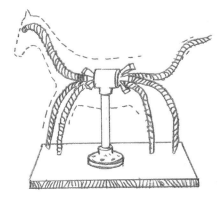

figure 3 (animal armature)

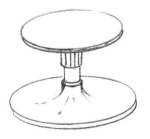

figure 4 (small rotating stand)

figure 5 (height-adjustable stand with rotating platform)

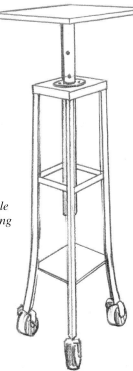

Portrait Armature

To make a portrait armature from scratch, you will need the following materials:

a) One 15" x 15" x 2" block of wood for a base

b) One 4" x 4" x 9" block of wood

c) Four triangular pieces of wood, roughly 3" x 3" in base and height and 1" in thickness for support (refer to the sketch at right)

d) Four small pointed wood wedges (roughly 3" in length)

e) Several meters of 3mm malleable galvanized wire (available in most hardware stores)

f) Two or three small wood butterflies which you can easily make by nailing two small pieces of wood together in a cross shape (using very small nails or tacks)

g) Thin wire (approximately 1 to 2 mm in diameter)

h) Several nails of variable length (1" to 3")

These items can be purchased at art supply, lumber, or hardware stores. Once you have obtained the proper supplies, erect your own armature as explained below.

1. Drill a hole in one end of the 4" x 4" x 9" wood block. The hole should be approximately 2" in diameter and 1.5" to 4" deep.

2. Nail the wood block, with the hole facing up, to the center of the 15" x 15" x 2" base. Then nail down the four triangular pieces of wood to support the block, as shown in the illustration.

3. Cut off two 24" pieces of the thick galvanized wire. Then wrap thin wire around the larger wires, as shown. The thin wire creates a surface to which the clay will adhere.

4. Bend each of the large wires into an oval shape, leaving 1.5" to 2" of straight wire at the ends. Then put the wire ovals together at a right angle, (as shown in the accompanying figure) to create an elongated, three-dimensional spherical shape (like a human head).

5. Use a length of thin wire to wrap the ends of the large wires together, and then insert them into the hole in the wooden block.

6. Stabilize the wire structure with the small wooden wedges (refer to illustration).

7. Use wire to suspend several small wood butterflies from the armature, as shown in the illustration. The butterflies allow for better adhesion of the clay or plasteline.

Note: The armature demonstrated here is for a life-size portrait. If you would like to make a larger or smaller portrait, you must adjust the lengths of the galvanized wires and the sizes of the other materials accordingly.

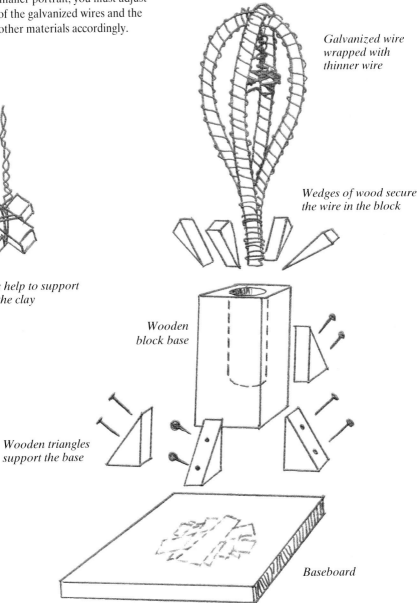

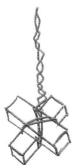

Galvanized wire wrapped with thinner wire

Wedges of wood secure the wire in the block

Butterflies help to support and hold the clay

Wooden block base

Wooden triangles support the base

Baseboard

Figurine in Solid Terra-Cotta

(Approximate size: 8" x 4" x 6")

Most modeling sculptors begin by working with clay or terra-cotta. Generally, the beginning phase of sculpting consists of simply playing with the medium until a certain passion manifests itself; this then continues until a figure is finally born.

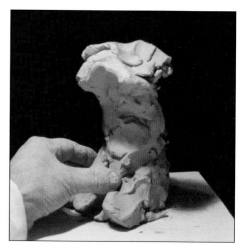

figure 1

All you really need to get started is a block of wood to use as a base, a hunk of clay, and plenty of passion and patience for what you are about to undertake. For these types of sculptures (that is, those in solid terra-cotta), armatures are not used.

In the accompanying illustrations I have simply plopped down a hunk of clay on a piece of wood. My intention is to model a female figure in a sitting position. If you are a beginner, I recommend starting with this position because the model will support itself nicely, allowing you to work comfortably.

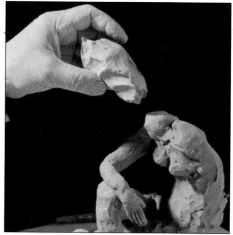

figure 2

For this exercise, your hands and your imagination will be the principal tools for shaping the figure. The important thing is to continuously shape and rework the terra-cotta until you acquire the ideal shape for your piece. It is only then that you should concern yourself with details such as the proportions and extremities.

Note: If you must take a break from sculpting for any length of time, be sure to cover your statue with a cellophane wrapper or ordinary plastic wrap. When you wish to continue working, simply uncover the piece and soften the clay with water.

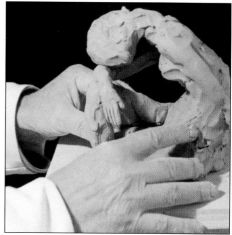

figure 3

12

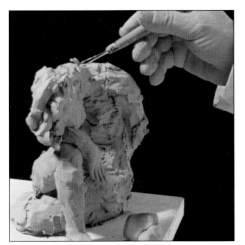

figure 4

After several hours of working the clay, it will begin to consolidate (harden). The firmer consistency will make it easier to work on details such as the hands, feet, or facial features. Try not to overwork your sculpture. It is usually considered more "artistic" to leave the model in a state of near-completion, creating the perception of a quick and impressionistic work.

Figure 5 shows a nearly completed first attempt. I am somewhat satisfied with this model, but I have to admit that I'll probably change my mind as time goes on.

When you are completely satisfied with your figure, leave it uncovered for three to four weeks to desiccate (dry). Once it is thoroughly dry, you need to bake it in a kiln at 2185-2265°f for approximately 8-10 hours. If you do not have a kiln at your disposal, ask your local art dealer for details concerning the use or purchase of one.

The completed model in solid terra-cotta is shown in figure 6. You can leave it as is or apply a patina as explained on pages 57 through 61.

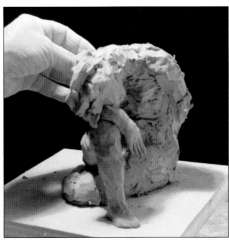

figure 5

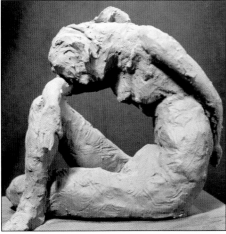

figure 6

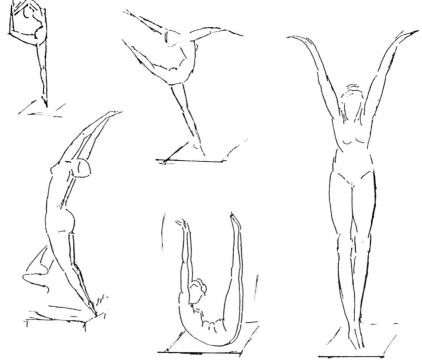

Ideas in Wax

As a medium, wax is similar to clay, but there are several different types of wax for many different purposes. Very hard waxes are commonly used for fusion (i.e., melting) in bronze; moderately hard varieties are used for retouching pre-existing work; and very soft varieties are commonly used for modeling. Wax can be obtained directly from a foundry. To locate a foundry in your area, simply look under "Foundries" in your business telephone directory. If they don't carry the soft wax that you need, they should be able to direct you to a place where you can get some.

Wax is an economical and relatively easy material with which to work. Armatures are not needed when working with wax, and, once the piece is completed, virtually any foundry can reproduce a finished model for you without going through the tedious and time-consuming processes of molding and casting. (Note: A wax figurine is not considered to be a final, permanent work of art; see page 17.)

Before working with wax, I usually spend some time sketching various subjects in a variety of positions. These drawings often enhance my creativity, helping me choose a subject to mold. Once I start working with the wax, however, I may or may not refer to the sketches. I usually prefer to let the figure develop on its own. This makes it more "artistic."

Moreover, at the beginning stages of a sculpture, I rarely worry about size; I have found through experience that this is one detail which typically takes care of itself during the course of the work.

A Model in Solid Wax

(Approximate size: 10" x 4" x 5")

Once you have obtained the wax from your local foundry and have decided on a subject to mold, you can get started (figure 1). First equip yourself with a small container of boiling water, and then break up the wax into small pieces and immerse them in the boiling water. Allow the wax to soak for five or ten minutes, or until it is soft enough to mold (it should have a "pasty" consistency).

figure 1

Carefully remove the wax from the water with a large spoon, and immediately start working with it (figure 2). Caution: the wax will be fairly hot.

Once you begin working, keep in mind that wax, unlike clay, requires that you work swiftly because it hardens as it cools. If it hardens before you are finished, however, simply submerge the model in a bucket of tepid water until it is soft enough to continue working. You may have to repeat this procedure several times, but it won't harm the piece in any way.

figure 2

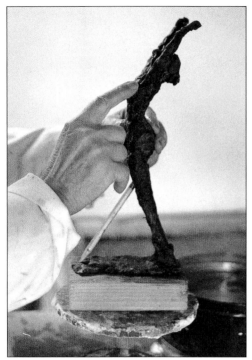

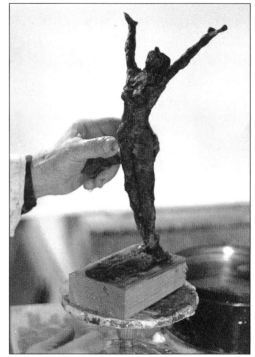

figure 3 *figure 4*

Start this figure by quickly shaping the torso and then attaching it to a flat plain of wax. Then, using more wax, quickly shape the arms and legs and attach them to the torso. (They adhere fairly easily if the wax is hot enough.) As you can see in the accompanying figures, the model slowly develops and acquires more form as you diligently work and rework the wax (figure 3).

Once you are satisfied with the basic form of the figure, refine it with a spatula or other tool, as necessary (figure 4). For example, you may want to develop the hands or add details to the face. I rarely add much detail to wax figurines; I prefer to leave them in an impressionistic state.

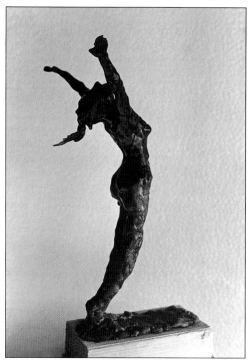

figure 5 *figure 6*

Once the model is complete, you can apply heat to it to give it that "final touch." This is easily done with a small propane gas torch (available at most hardware stores). The heat causes the wax to contract slightly, taking on a touch of artistic sophistication (figure 5). Additionally, if you later decide to have the figurine cast in bronze, this procedure will enhance the patina, giving the piece a finish of the finest quality.

When using the torch, hold it from 10-12 inches away from the figure; the flame should never touch the piece. If any part of the figure begins to melt, quickly move the torch to another section of the piece. Do not hold the torch in any one area for more than a few seconds; you can easily ruin the piece, and all of your hard work and creativity will be wasted. (Note: An electric hair dryer can often be used in place of the torch, but it will not provide optimum results.)

Wax figurines must be cast in bronze if you wish to display them for long periods of time at room temperature. Otherwise, they must be stored in a cool place for preservation. In addition, if you do decide to have the figure cast in bronze, you will need to eliminate the base (or have the foundry do this for you). These wax figurines are usually only practice models used for developing sculpting skills; I rarely have them cast in bronze, unless, of course, one turns out to be a real masterpiece. Most of the time, I simply store finished wax pieces in a refrigerator for later reference.

The Bas-Relief

(Approximate size: 10" x 10" x 0.5")

A bas-relief is a sculptural relief in which the projection from the surrounding plane is slight and the modeled form is not undercut. In sculpture, the bas-relief is probably the most versatile form of expression because it allows the sculptor great flexibility. I doubt that there is a sculptor around who hasn't, at some time or another, made a bas-relief, either as a divergence from more traditional expressions or as a result of a specific commission. One of the most famous bas-reliefs is Lorenzo Ghilberti's "Porta Del Paradiso" (so named by Michelangelo), which is on display at Battistero in Florence, Italy.

We will now create a bas-relief, make a mold for it, and then cast several editions from the mold. Before getting started, you will need a small plane of wood (approximately 20" x 20" x 1.5") and some plasteline. Fortunately, the bas-relief is easy to work with, needs little care, and, most importantly, the plasteline remains soft, so it is easy to work and rework.

The first step is to create a plane of plasteline for the relief. You can easily do this by drawing a rectangle on your board and then filling it in with about 0.5" of plasteline (figure 1). If you wish, use a spatula to smooth the surface of the plane.

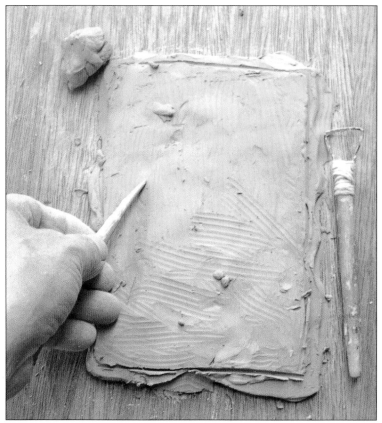

figure 1

Now begin to carve out the subject (figure 2). I have chosen a mother and child "maternity group." For your first attempt, you may want to choose a very simple sketch; as you become more experienced, you can try more intricate subjects.

It is usually helpful to draw your subject on a piece of paper before working on the plasteline. This will not only serve to refine your drawing, but also to make it easier for you to etch it into the plasteline because you will be more familiar with it.

After etching the figure, build up your plane with more plasteline to project a three-dimensional figure of the group (figure 3). Do not worry about making mistakes, because with plasteline you can simply "erase" any mistakes by rubbing them out with your hand or a small spatula.

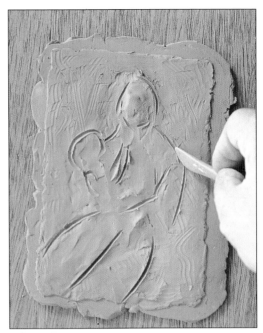

figure 2

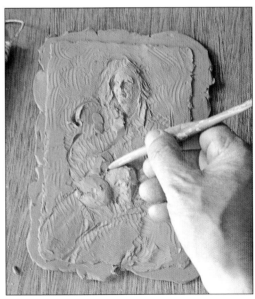

figure 3

Now begin to add details to your design so that it begins to look like a true bas-relief (figure 4). It is important at this stage to *think* before applying the tool to the plasteline and to proceed slowly. Note that the surface of the bas-relief in this illustration is much smoother than in the previous steps. This was accomplished by smoothing out the plasteline with a small spatula.

Once the bas-relief is complete (figure 5), you are ready to make a mold of it. The mold will enable you to make copies of your work.

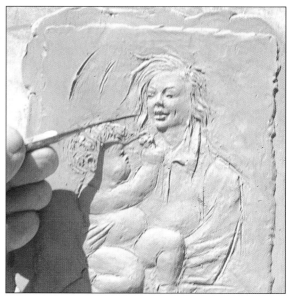

figure 4

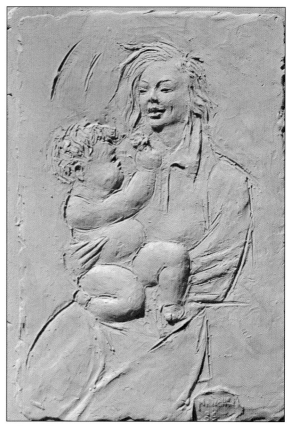

figure 5

To make a mold of the bas-relief, you must pour liquid plaster of paris over your piece, allow it to dry, and then remove the plasteline from the plaster, leaving an imprint of the sculpture in the plaster. This process is explained below.

First apply a thin coat of petroleum jelly to the underlying board of your bas-relief (the petrolatum allows the plasteline to separate easily from the plaster once the plaster has dried). Then use strips of plasteline (approximately 2" high and 0.5" thick) to build a "wall" around all four sides of the plane of the bas-relief (figure 6). This wall creates a "moat" around the plane, which will serve as a container for the liquid plaster.

Next, mix some plaster of paris with enough water to create a smooth, runny, batter-like consistency. Then pour the plaster mixture over the bas-relief until the entire figure is covered and the "moat" around the plane is filled (figure 7).

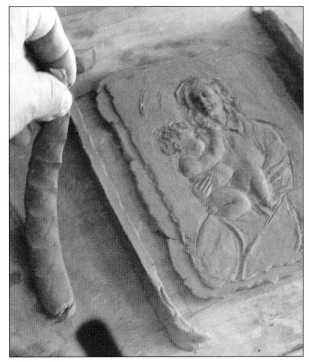

figure 6

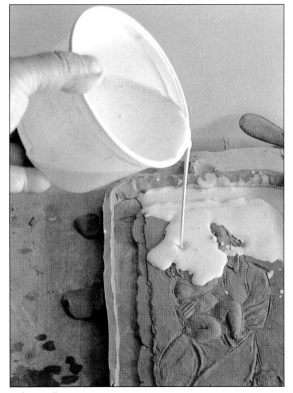

figure 7

The liquid plaster should reach the top of the plasteline wall which, again, should be about 2" high (figure 8). Allow the plaster to dry completely; to be safe, wait at least 4-6 hours.

Once the plaster is completely dry, carefully turn the piece over, and gently remove the new plaster mold from the original plasteline carving (figure 9). Pick off any remnants of plasteline from the plaster mold, and then dust the inside of the plaster mold with talcum powder.

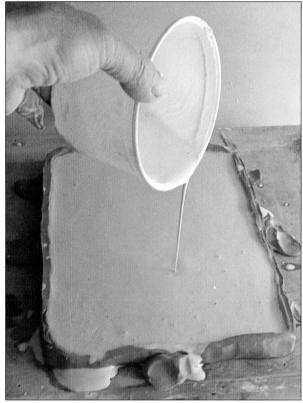

figure 8

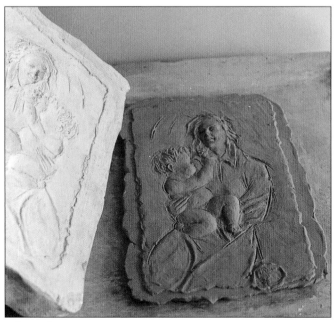

figure 9

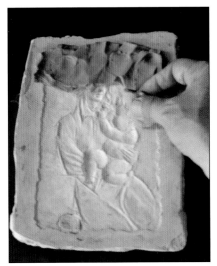

figure 10

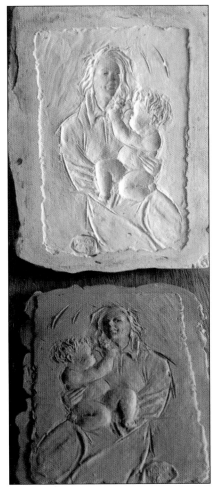

figure 12

figure 11

You will now use the plaster mold and terra-cotta to make copies of the original plasteline carving.

Carefully press small pieces of terra-cotta into the mold (figure 10). Apply slight pressure, but be careful not to damage the intricate details of the mold. Continue until you have filled the mold with approximately 1" of terra-cotta (figure 11). Then allow the terra-cotta to dry. After several hours, the terra-cotta will begin to separate from the mold; at this time, use a spatula to carefully remove the model from the mold (figure 12).

You may find that you need to retouch the extracted terra-cotta model; for example, you may need to use a spatula or your finger to "fix" some of the details of the model.

Allow the terra-cotta model to dry thoroughly (approximately 1 or 2 weeks), and then bake it in a kiln for 8-10 hours, at 2185-2265°f. If you do not have a kiln at your disposal, ask your local art dealer for details concerning the use or purchase of one.

When the piece is cool, you can either leave it as is, varnish it, or apply a patina (see pages 57-61).

Proportions of the Human Body

The size of the human body may be measured accurately and conveniently using head size as a standard unit. With this measure, the adult body is approximately 7.5 heads tall.

The Male Figure

Figure 1 shows the proportions of the male figure. The widest part of the body is the upper back (including the shoulders) which measures approximately 2 head widths. The length of the trunk of the body is roughly equal to 3.5 head sizes, while the length of an arm, as measured from the center of the face to the tip of the middle finger, measures almost 4 heads. The portion of the legs between the hips and the knees is roughly equal to 1.5 heads, whereas the bottom of the legs, from the knees to the ankles, measures approximately 2 heads.

The length of the male hand is roughly equal to the length of the face, as measured from the center of the forehead to the tip of the chin. Finally, the weight of the male muscles of a flexing athlete are roughly equivalent to one half the total weight of the body.

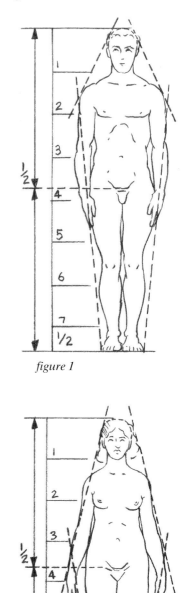

figure 1

The Female Figure

A sketch of the female figure is shown in figure 2. The female body is generally smaller than its male counterpart. The widest part is the hip area, which measures 2 head sizes in width. The upper back usually measures 1.5 head sizes. The waist, as viewed from the front, measures roughly 1.25 head sizes. In contrast to the male figure which is blocky in outline, the female figure is round and graceful.

The Infant Figure

The head and stomach of an infant are disproportionately large in relation to the rest of the body. In contrast, the neck is very short and narrow. Moreover, the development of the body is much more accelerated with respect to the head.

figure 2

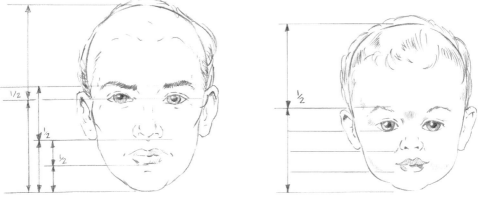

figure 1 figure 2

Proportions of the Human Head

The Adult

A sketch of an adult head is shown in figure 1. The eyes are located halfway between the top of the head and the tip of the chin, and the distance between them is equal to the width of one eye. The nose is located in the center of the face (as opposed to the whole head), and its length is approximately one-quarter the length of the head. The collective width of the nostrils is approximately the same as the width of one eye. The length of the ears can be easily approximated because they generally extend from the eyebrows to the tip of the nose. The lips are located between the bottom tip of the nose and the tip of the chin. The bottom lip is usually drawn on a center line between them. Their width is approximately equivalent to one and one half times that of one eye. Finally, the size of the neck is usually one half the size of the head, but this proportion varies greatly and, in some cases, may be as large as three-quarters the size of the head.

The Infant

A sketch of an infant's head is shown in figure 2. In relation to the rest of the body, a baby's head is much larger than that of an adult. The eyes are very large; they're not indented but lie closer to the plane of the face. The nose usually appears squashed, and it is rounded at the tip. The lips are very small, and the upper lip normally protrudes over the lower lip, giving the impression of an overbite. The infant's ears are generally the same as an adult's in that they extend from the eyebrows to the tip of the nose, but they are different in the sense that they are more fleshy and less "unraveled" than those of an adult.

The Portrait

From a conceptual viewpoint, the important aspects of the human figure are the proportions, form, and movement (remember the wax ballerina?). In contrast, the success of a portrait depends on its resemblance to the person you are trying to portray.

The Components of a Portrait

For a portrait sculptor, whether a novice or seasoned veteran, the most difficult and time-consuming elements are the four features illustrated here: the mouth, nose, ears, and eyes. In addition to the difficulty of actually sculpting these components, there is the problem of what I call the "interpretation issue." I have found that it is extremely difficult to correctly interpret the expression of the subject as revealed through his or her facial features. Yet, this is critical to the success of the piece. In particular, the interpretation of the eyes can either bring "life" to the portrait or cause its total failure. Before beginning to sculpt any facial feature, it is helpful to practice modeling it on a plane of plasteline without regard to the rest of the portrait. The following exercises have been very helpful in my personal work, and I have decided to share them with you in the hope that they will help make you more confident when approaching your first portrait.

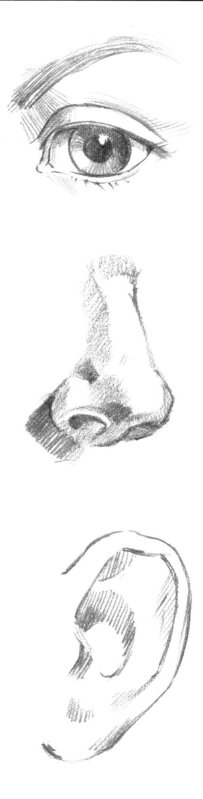

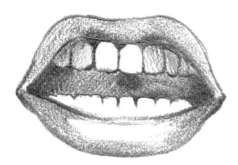

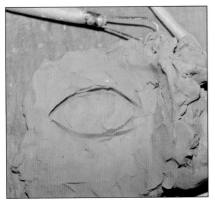

figure 1

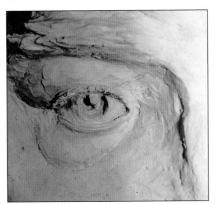

figure 2

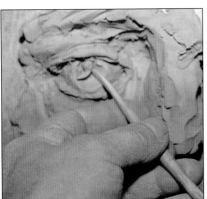

figure 3

figure 4

The Eye

The eye is probably the most difficult component of a portrait to model. The accompanying figures demonstrate the proper procedure to follow when sculpting the human eye. Use a small spatula to carve out the general eye shape on a plane of plasteline, as shown in figure 1. Scoop out a small depression in the center of the shape to form the base of the eyeball. Then, using your fingers, add more plasteline above and below the eye shape to build up the eyelid and the bag below the eye (figure 2). Add a small comma-shaped piece of plasteline in the center of the depressed area to establish the pupil (figure 3). Finally, as shown in figure 4, build up the eye by adding more plasteline, creating a three-dimensional perspective.

Once you have accomplished the basics, it is extremely important to spend plenty of time refining your work. Use different tools to complete various modifications, and add or subtract material as needed. Take your time with your first attempt at sculpting an eye. When you feel you have perfected your first attempt, you are ready to start on another, larger eye. A larger example will allow you to practice your detail skills. Note: You may find it helpful to study your own eye in a mirror. This will allow you to closely observe the detailed components of the eye. (Bear in mind, however, that the mirror image is reversed from the view others have of you.)

The Nose

The nose may be the most unique feature of the face. Begin by forming the basic shape out of plasteline (figure 1). The easiest way to do this is to begin with a long, trianglular shaped mass of clay. Of course, the exact dimensions will be portrait specific, but the base of the triangle should be roughly 1/3 the length of the sides.

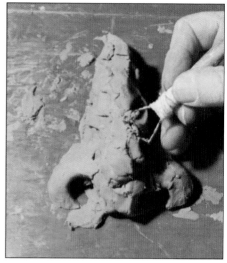

figure 1

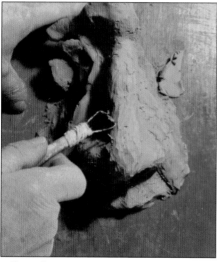

figure 2

Next, carve out two nostrils with a sculpting tool or your pinky fingernail, as shown in figure 2. At this point, the nose is basically finished, and you simply need to continue working the basic shape until you arrive at the desired degree of similarity to the portrait or piece in question.

Figure 3 shows the completed model.

As with the eyes, a mirror in front of your face may help you while sculpting the nose. Therefore, don't hesitate to use this method again and again.

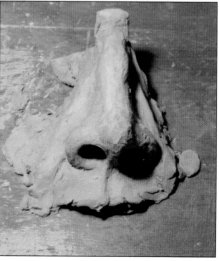

figure 3

The Ear

Compared to the eye, the ear is not difficult to model because ears are not usually crucial for achieving a likeness. As a result, you will find that the ear will rarely be a critical aspect of your project.

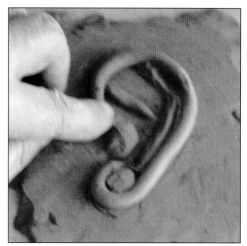

figure 1

As shown in the sequence of figures on this page, the initial step is to roll out a long, thin piece of plasteline and place it on your working base in the shape of an ear. The major difference between a given individual's ear and a "generic" ear will usually be the earlobe, which may be attached or unattached. Then add a second, smaller piece of plasteline along the inside of the first piece, as shown in figure 1. The rest of the procedure simply consists of working and refining the plasteline into a smooth-textured, natural looking ear, creating a three-dimensional perspective, as with the eyes (refer to figures 2 and 3).

I commonly observe my own ears while working, and, though this is a bit trickier than observing my eyes or nose, I have found the process to be very useful.

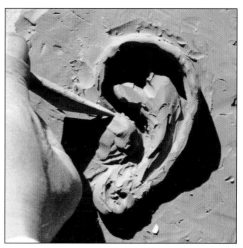

figure 2

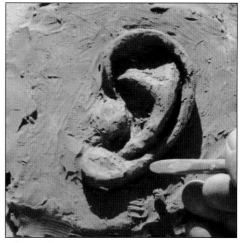

figure 3

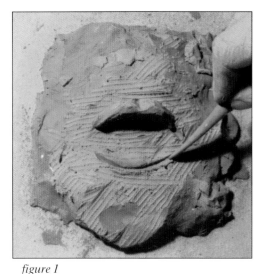
figure 1

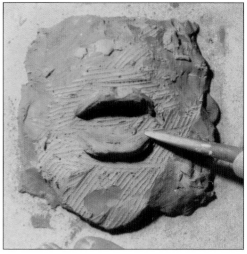
figure 2

The Mouth

First establish a working mass with plasteline to represent the lower face. Then construct the mouth by placing a large, half-oval strip of plasteline on this surface to form the upper lip (figure 1). Next, add some clay for the lower lip, and use your tools and fingers to shape the lips (figure 2). Then carve out a depression in the center to form the opening of the mouth (figure 3). Build up or add small strips of plasteline to represent the mass of the tongue and teeth. Develop the shape of the upper lip and chin. At this point, lightly carve in the outline of teeth. Notice that the upper teeth are slightly wider than the lower teeth. In figure 4, the mouth is basically complete and simply needs to be refined. It is important to work on a larger mouth after completing your first attempt.

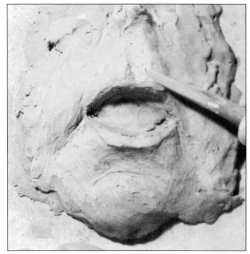
figure 3

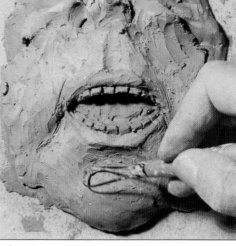
figure 4

A Study of the Hand

It can be difficult to execute a hand that is both in harmony with a figure's particular movements and in correct proportion to the rest of the body. Because there is an infinite number of hand positions, making the position correspond with the figure's expression requires a considerable amount of patience and time. Numerous studies are required before the proper results can be obtained, and, initially, mistakes should not be a concern. As you can see, most of my "studies" are not all that remarkable, but they were helpful because each study brought me one step closer to the desired, though unknown, result.

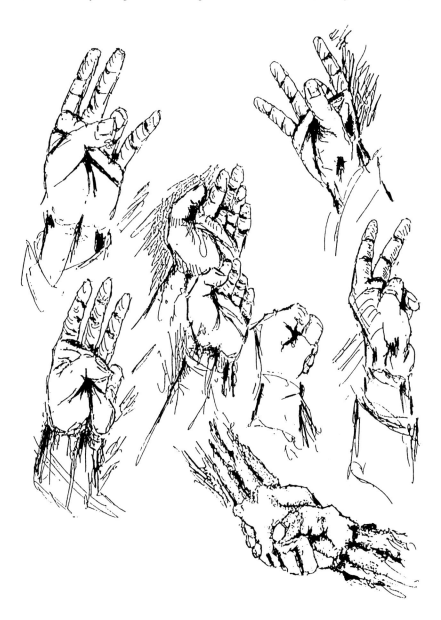

The Hand

(Life-size)

The hand shown here was modeled out of wax rather than plasteline (see page 15 for information on preparing the wax). The wax allowed me to practice without using an armature; all I needed was a steel rod nailed to a wooden base, which allowed for easy adhesion of the wax.

To construct a hand with this type of setup, mold the palm, along with a small protrusion for the thumb, around the steel rod. Then add the index and pinky fingers (figure 1). Next, begin molding the middle and ring fingers (figure 2). When constructing the fingers, remember that fingers are divided into sections. From a sculpting perspective, these sections simply consist of cylinders of equal length, which are joined at the knuckles. The thumb is made up of two cylinders, and the rest of the fingers are made up of three cylinders. In figure 3, the hand is basically complete and merely needs refining. Figure 4 shows the final piece cast in bronze.

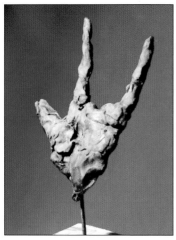

figure 1

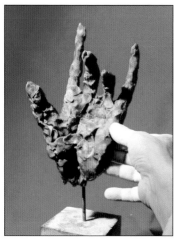

figure 2

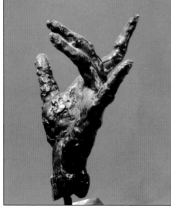

figure 3

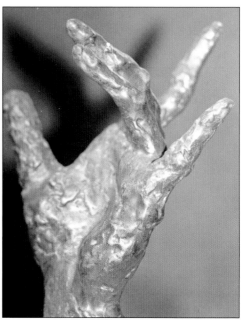

figure 4

The Lost-Mold Method

Before embarking on a detailed discussion of the various techniques and processes used in sculpture, an introductory note is required.

A modeling sculptor generally works in a soft medium, such as clay or plasteline, and then converts the finished piece into a hard, permanent medium, such as plaster. Traditionally, this conversion is accomplished with a process known as the "lost-mold" method, which can be used to reproduce *any* kind of sculpture: a portrait, a figure, a group of people, an animal, etc.

The lost-mold method, however, involves a lot of hard work, is time-consuming (because it involves so many steps), and requires considerable experience to master. Consequently, in the following demonstrations, the lost-mold method of reproduction has been excluded. Instead, easier, faster, and more innovative processes for converting original "soft" models into permanent, hard statues have been explained, including the unique original (hollow terra-cotta), the three-piece stampo, and the semi-hollow terra-cotta methods. These techniques eliminate the need for the more time-consuming and difficult lost-mold method; yet, they yield the same results, and, therefore, are better suited for beginning sculptors.

A detailed discussion of the lost-mold method would require many more pages than are available in this book and would be better suited to a more advanced book on sculpture. Nonetheless, a brief description of the method is included on page 49 for interested readers.

With this important caveat, let us now begin sculpting.

The Birth of an Original Portrait

(*Gary, "The Little Champion"*)

A portrait sculpture can be a painstaking endeavor for any artist. Because a portrait is very easy for others to judge, it represents a kind of "test" for many sculptors. The best way to get started on a portrait is to study the subject during live posing sessions under the appropriate lighting conditions. A common approach is to make a great number of sketches of the subject in a variety of poses and from different angles. These sketches are used to familiarize yourself with the subject, focus your intent, and ease the overall execution of the model.

Another method is to study the subject by way of photographs. Naturally, this is a more difficult task and requires a greater amount of study and drawing, but it is often the only option. For example, if you were commissioned to sculpt a portrait of a world leader, he or she may not have time for a lengthy posing session.

The important point is that you must gain a thorough understanding of your subject before you can begin sculpting. Ultimately, this seemingly time-consuming procedure will actually save you a lot of time, as well as frustration.

I believe that a portrait of an infant is, by far, the most difficult to simulate through sculpture. This is because an infant's facial features can change daily—unlike those of an adult which change over much longer periods of time.

A Portrait in Hollow Terra-Cotta

(Life-size)

The hollow terra-cotta method is one in which you use a removable paper armature, rather than a wire armature. This eliminates the need for making a cast of the portrait by using the complicated and time-consuming lost-mold method (see pages 33 and 49). The hollow terra-cotta process is also less expensive than other techniques, and it preserves the portrait EXACTLY the way it was sculpted—down to the last detail. Moreover, since the original piece is done in terra-cotta, it is much more durable than the plaster used for the lost-mold method; yet it can still be cast in bronze, if desired.

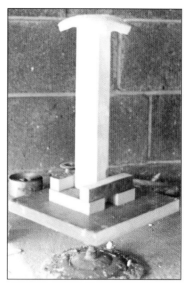

figure 1

There are, however, some disadvantages to this procedure: It is a relatively difficult process to learn, so it is usually only attempted by those who feel they have a fair amount of experience, and it can be used only for fairly small portraits (up to life-size). These problems notwithstanding, I always encourage beginning art students to try this method over and over again until they master it.

As noted, you will need an armature to support the hollow terra-cotta portrait. This type of armature is not available commercially, but, fortunately, it is easy to make. You will need a 12" x 12" x 2" wooden base, a 3" x 3" x 20" wooden column, four 1" x 1" x 6" small rectangular blocks, and one small, dry sponge. Nail the wooden column to the center of the wooden base; then nail down the four rectangular blocks for support (figure 1). Glue the sponge to the top of the wooden column, and then mount the entire armature on top of a rotating platform. Once the base is attached to the rotating platform, cover the top of the wooden column and sponge with several layers of newspaper (figure 2). Use rubber bands to secure the newspaper to the armature. The objective is to produce a fairly compact ball of paper around the armature. The paper will not only provide a support, but it will also prevent the terra-cotta from cracking once it dries and contracts.

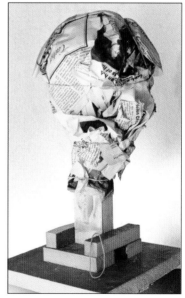

figure 2

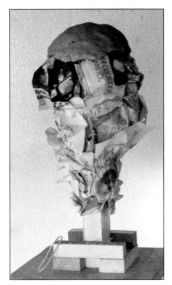

figure 3

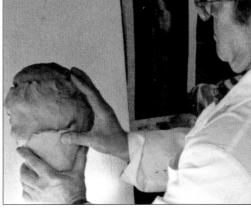

figure 4

Mounting the Terra-Cotta

Flatten and mold several pieces of terra-cotta into pancake-size shapes, approximately 4-6 inches in diameter. Then use these shapes to cover the surface of the paper ball armature. The first of these pieces, placed on top of the head, should be a bit thicker than the others because it is the piece to which the others will be attached (figure 3). Use your hands to blend and mold the terra-cotta pieces around the armature (figure 4). The objective here is to create an elliptical framework for your portrait. Do not concern yourself with details at this stage; simply make sure that the paper armature is completely covered with the terra-cotta. When the entire surface of the paper is covered, as shown in figures 5 and 6, let the terra-cotta dry for at least 4-5 hours—but preferably overnight.

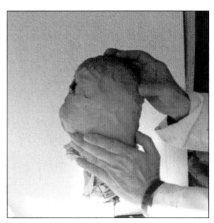

figure 5

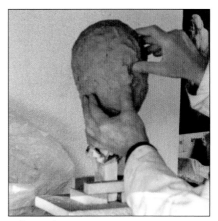

figure 6

Modeling the Portrait

Once the working model is established, each phase of the portrait is completed the same way: material is added, removed, reshaped, and refined, as necessary (refer to accompanying figures 7 through 9). You have already meticulously studied and sketched your subject, so once the oval terra-cotta "skull" is ready, you can concentrate on creating the specific characteristics of your subject. For example, if the subject has a lot of hair, you may want to begin by adding more material to establish the hairline, ponytail, mohawk, braids, et cetera. If the subject has exceptionally meaty cheeks, you may want to add additional material in the appropriate spots to accentuate them (lightly spray or mist the skull with water to insure adhesion of added material).

If you find that you need to reshape the terra-cotta skull—for example, if your subject's head is slightly rounder—you can use a mallet or small piece of wood to gently tap it into shape. Be very careful while doing this, however, because if you tap too hard, you might crack the clay skull.

When you're done working for the day, the model may be left out, uncovered, without any consequences, especially during times of high humidity. Once the portrait is in its advanced stages, however, it is best to cover it with a cellophane bag at the end of the day. For the next session, soften the terra-cotta by lightly spraying it with water and continue working.

If you feel that you need to take a break and rejuvenate your creativity, let the portrait sit for several days without working on it. This should not present a problem as long as you cover it with cellophane for the duration and remember to wet it before returning to work.

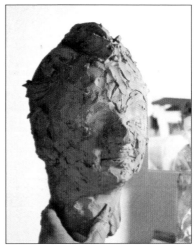

figure 7

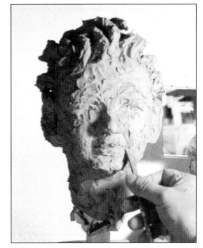

figure 8

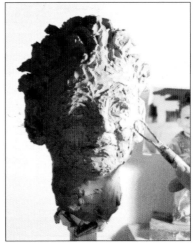

figure 9

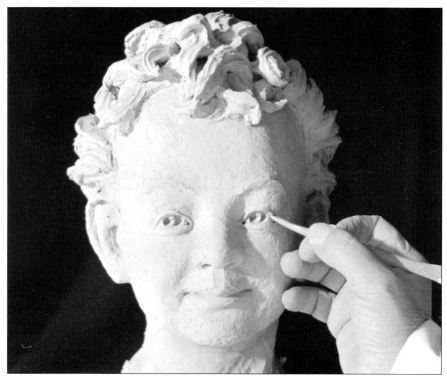

figure 10

Once the portrait has reached a certain level of sophistication, it is necessary to establish the exact position of the eyes, nose, and mouth (figure 10). Refer to pages 26-30 for tips on sculpting these elements. Once you have completed the ears, nose, mouth, and eyes and are refining the portrait, it is very important to concentrate on the details of the eyes and the area around the eyes. You will find that most of your time will be spent on these areas; it is not only the most difficult part, but, in many cases, the likeness of the portrait to the subject depends upon it.

This last step is the most crucial, and it is important at this point to stop working and contemplate the piece: Are the eyes as round as those of the subject? Is the mouth as big as that of the subject? Is the hair the same? What about the nose? and so forth.

These are observations that only you have the ability to make, and the judgments you make concerning these details will contribute to the originality of your portrait. During this stage, I often find myself observing the portrait for days and days at a time because I am simply not satisfied with its likeness to the subject. At this stage, the most precious elements you have at your disposal are your own eyes and hands and your will to succeed. Perseverance is the key!

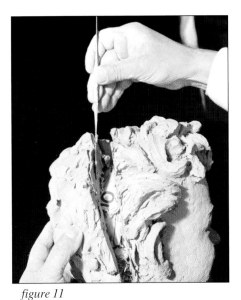

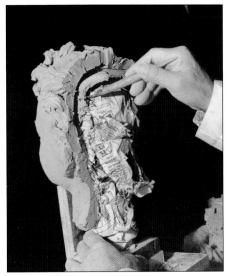

figure 11

figure 12

Removing the Armature

Once the portrait is complete, the armature must be removed. This step can be rather difficult and requires some practice. First initiate the division of the model by using a spatula to cut through the terra-cotta, down to the paper armature. Then use the spatula to separate the two pieces. Never twist the spatula in your attempt to separate the piece; instead, cut the piece along the division line, over and over again. As you continue this process, the portrait will eventually split in half (figure 11).

Note that the model should be separated in such a way that the ears remain on the facial half of the portrait.

This procedure should be performed with extreme caution; take your time, and do not try to force the separation; forcing the piece apart, even slightly, will ruin it.

To remove the armature, use the spatula to carefully carve out a layer of terra-cotta around the perimeter of the paper armature. To make the removal of the armature easier, cut out a relatively thick layer of terra-cotta (figure 12).

Note: During this process, be sure to support the portrait with a piece of wood, as shown.

Thinning the Terra-Cotta

Once the paper has been removed, continue using the spatula to thin the inside of the terra-cotta portrait as much as possible. This involves scraping the insides, just as you would scoop out the inside of a pumpkin or a cantaloupe while preserving the rind. The objective here is to minimize the overall thickness of the terra-cotta (to about .75") and to create a uniform thicknes.

Reattaching the Portrait

To reattach the two pieces, place some dry terra-cotta in a small bowl of warm water and let it soak until it acquires a paste-like consistency. Then use a spatula to apply the pasty terra-cotta around the edges of both halves of the model (figure 13), and carefully place the pieces back together. Quickly turn the portrait upside down and place it in a plastic container (figure 14).

Next fill in all gaps, applying fresh terra-cotta to both sides of the seam. Let the piece dry for 3-4 hours, and then turn it right side up and place it on a temporary base—for example, a piece of wood. At this point, you can lightly spray the piece with water and add final touches, fix mistakes, or make slight changes (figure 15). Once you are satisfied with the portrait, allow it to dry for 3-4 weeks. Once it is thoroughly dry, bake it in a kiln at 2185-2265°f for approximately 8-10 hours. If you do not have a kiln at your disposal, ask your local art dealer for details concerning the use or purchase of one.

After baking, the portrait is ready for the patina (refer to pages 57 through 61). In the examples on page 41, the portrait has been painted with a bronze patina.

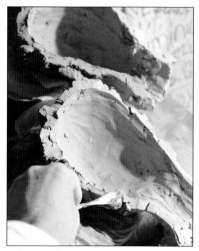

figure 13

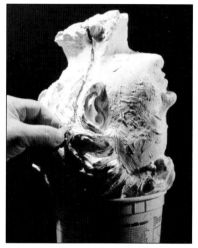

figure 14

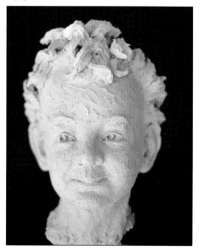

figure 15

figure 16

Mounting the Portrait

The final step is to mount the portrait on a wood base. You can either purchase a finished base at an art store or buy an inexpensive block of wood at a lumber store. (If the wood is unfinished, be sure to paint and varnish it before placing your portrait on it.)

To attach the portrait to the base, hammer 2 or 3 nails into the wood, leaving about one-half of the nails exposed. (Note: Use strong, 3-4" nails.) Then put some pasty plaster on the nail heads and the underside of the portrait (figure 16), and quickly place the portrait on the base. Hold the model in place with temporary supports—for example, a couple of hammers or mallets—and let the plaster dry for 3-4 hours (figure 17).

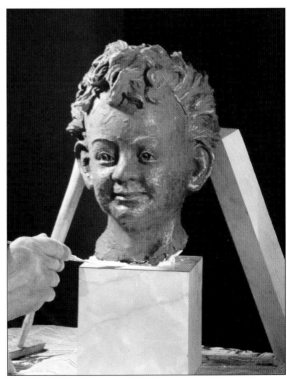

figure 17

The Little Champion is complete!

The Three-Piece Stampo

(One half life-size)

If you create a portrait of which you are especially proud, you will probably want to make reproductions of it. The three-piece stampo is a common molding/casting method that allows you to reproduce an original work without having to resort to the more traditional, commercial methods, such as the lost-mold method (pages 33 and 49). The three-piece stampo method can be used to reproduce the hollow terra-cotta model you created in the previous exercise, but it must be done before you divide the piece and remove the paper armature. It can also be used for portraits done in plasteline, clay, or terra-cotta, utilizing armatures similar to the one on page 11.

Note: This innovative technique is best suited for fairly small sculptures.

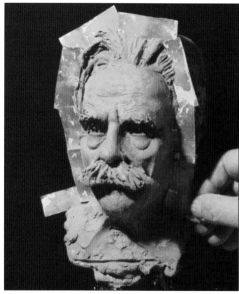

figure 1

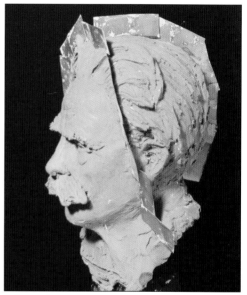

figure 2

To begin, divide your hollow terra-cotta portrait in half by inserting a series of thin brass platelets (available at any art or hardware store) into the terra-cotta, down to the paper armature (you can make your own shims by cutting a thin sheet of brass into uniform strips). Be sure to place the platelets in front of the ears to allow for easy extraction of the facial portion of the piece (figure 1).

Next, divide the back section of the model in half by once again inserting brass platelets directly into the terra-cotta (figure 2). The model is now divided into three pieces: the large, frontal portion and the two smaller back portions.

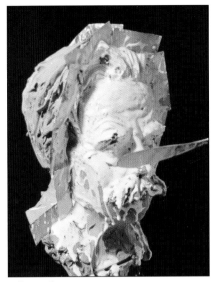

figure 3

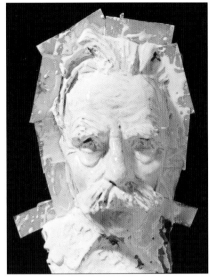

figure 4

Dissolve some plaster of paris in enough water to produce a smooth, runny, batter-like consistency. Then, using a large spatula, splash generous portions of the liquid plaster directly onto the model. (figures 3 and 4). Don't be concerned if the plaster seems to dry too quickly or if some of it runs off of the model. Once the piece is completely covered with one layer of plaster, blow on the model to eliminate any air bubbles that may have formed in the plaster.

Without waiting for the plaster to dry, repeat the process until the entire portrait is covered with five or six layers. The plaster should be approximately 1/2 to 1 inch thick. Clean off the top edges of the brass platelets after applying each layer of plaster (figure 5).

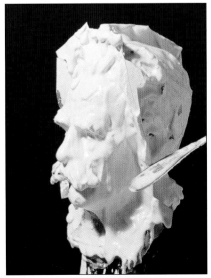

figure 5

figure 6

The completed stampo is shown in figure 6 on page 43. It is important to note here that the junctures that mark the positions of the brass platelets need to remain well defined.

Once the stampo is complete, allow it to dry for at least two full days before continuing. Then it is time to divide the plaster mold. Use a spatula to carefully separate the piece along the brass junctures, removing the plaster from the terra-cotta (figure 7). In most cases, you'll find that the pieces will be easily separable on their own. If this is not the case, however, using a spatula or a knife, you can easily separate the pieces by slowly applying pressure at the junctures and slightly twisting the knife. In any case, the separation should not be a problem. After the three plaster pieces are divided and removed, dust the insides with talcum powder, and allow them to dry for about one full day (figure 8).

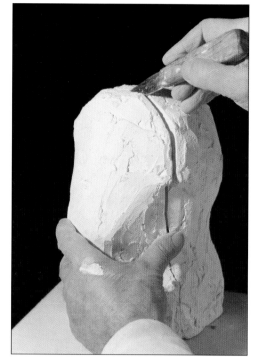

figure 7

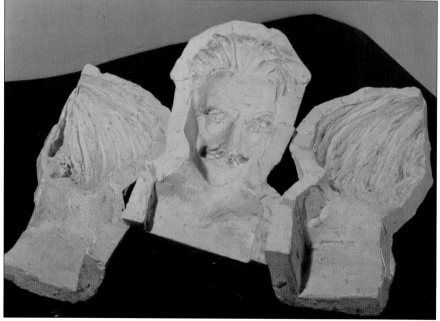

figure 8

Once the plaster mold is thoroughly dry, fill each of the pieces with terra-cotta (figure 9). One at a time, press small pieces of clay into the mold until it is filled. Slight pressure is needed to ensure that the terra-cotta fills in the details of the piece, but do not press too hard or you might damage the mold. After filling all three pieces of the mold with one half to one inch of terra-cotta, let them stand in the sun for four to five hours, or allow to dry overnight (figure 10).

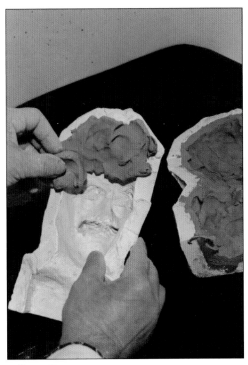

figure 9

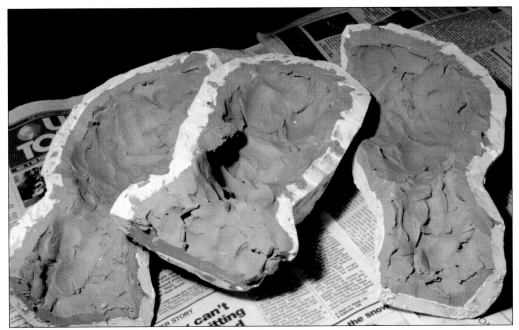

figure 10

Once the terra-cotta is dry, it can be easily removed from the plaster mold. Simply turn the piece over onto your workbench, and the terra-cotta will fall out of the plaster. If necessary, you can use a spatula or your fingers to aid in the extraction (figures 11 through 13).

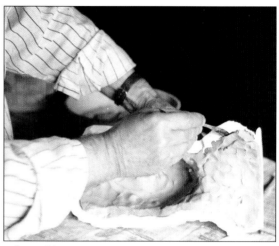

figure 11

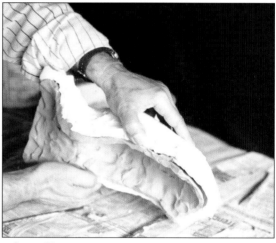

figure 12

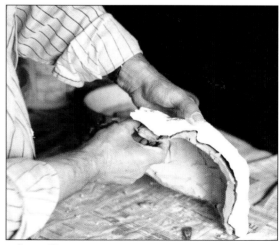

figure 13

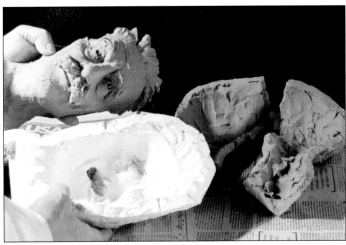

figure 14

Here the terra-cotta model has been removed from the plaster cast.

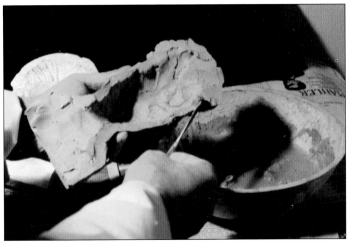

figure 15

Next, apply some pasty terra-cotta mixture to the edges of the mold to "glue" the parts back together.

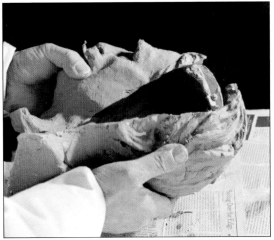

figure 16

Now fit the pieces of the portrait back together.

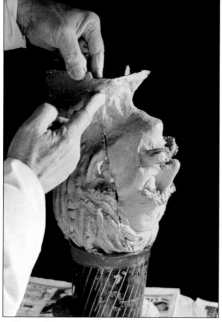

figure 17

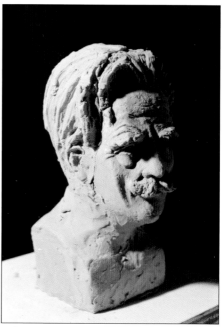

figure 18

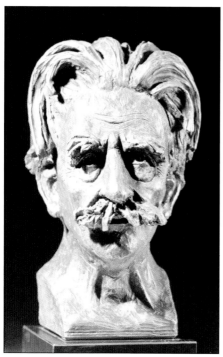

figure 19

Now the three terra-cotta pieces must be reunited. Fit the three pieces back together, and place the entire model upside down in a container. Then use a pasty mixture of terra-cotta and water to fill in the seams—both internally and externally (figure 17). Let the piece dry for 4 to 5 hours. For more detailed instruction on reuniting the model, see *The Little Champion* on pages 39-40.

Finally, turn the model right side up and, if necessary, add the finishing touches—for example, some of the details may have been damaged during the stampo process, so you will need to repair the damage (figure 18).

Allow the piece to dry for 2-3 weeks before firing in a kiln (see pages 13 and 23).

Figure 19 shows the finished piece after firing and staining with a bronze patina (see pages 58-59). This example is a study for a portrait of Albert Schweitzer; it represents the first piece in what may become a small edition of similar pieces.

The Lost-Mold Method in Practice

The traditional lost-mold method for reproducing clay or plasteline models in hard media (such as plaster) is virtually identical to the three-piece stampo method discussed on pages 42-48. There are, however, three important exceptions. The first is that, instead of splitting the sculpture into three pieces, it is split into two equal halves, making it suitable for any subject—not just portraits. The second is that the first layer of splashed plaster is "colored" by dissolving some powdered color (available at any art store) in the plaster. This color notifies you that the final sculpture is directly beneath this layer of plaster. The third is that, instead of making the reproduction in terra-cotta, it is made in plaster.

Again, the process is similar to the three-piece stampo: make an original sculpture out of terra-cotta or plasteline; divide the piece in half with brass platelets; splash with several layers of plaster, being sure, however, to "color" the first layer; let the plaster dry; separate the mold into two halves, and remove the original, soft sculpture.

You are then left with two pieces for the mold (instead of three). Coat the insides of the two pieces with a thin layer of petroleum jelly, and then fit them back together, secure with wire, and "glue" together at the seams with pasty plaster. Once the plaster is dry, you are ready to make the reproduction. Pour some liquid plaster into the mold, shaking the mold to insure an accurate imprint of the model. Then pour more liquid plaster into the mold to create a uniform thickness of approximately 1-2 inches.

After the plaster inside the mold dries (5-6 hours), use a mallet and chisel to chip away the outer layers of plaster. When you get to the colored layer, be very careful because it indicates that you are very close to your new model. Once the plaster mold has been completely chipped away, use some plaster to touch up any areas that were nicked or damaged. You now have a hard, permanent reproduction of your original, soft sculpture.

Notice that in retrieving the new sculpture, you "lost" your original mold—hence, the "lost-mold" method.

Semi-Hollow Terra-Cotta Figurines

(Approximate size: 24" x 10" x 12")

During the execution of semi-hollow terra-cotta models, the objective from the outset is to create a piece that is virtually hollow. This process conveniently eliminates the steps involved in the lost-mold method (see pages 33 and 49); consequently, the resulting piece is quite a bit lighter in weight. An important advantage with this method is that the final piece can be reproduced in bronze, just like any other original piece of sculpture. Once this type of sculpture is completed, however, it cannot be reproduced using the bas-relief or three-piece methods; it, therefore, remains a unique original.

For this discussion I have chosen to sculpt a figure composed of two young boys. If you have trouble choosing a subject, try looking through magazines or books to spark your imagination. If you still draw a blank, you may want to copy the example here. In any case, once you have chosen a subject, crumple and roll sheets of newspaper into appropriate shapes for the torsos and extremities of the figures. Then shape several small, flat, pancake-shaped pieces of terra-cotta clay (figure 1).

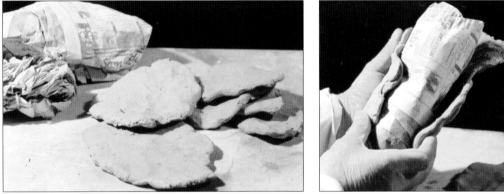
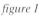

figure 1 *figure 2*

Wrap the clay (roughly 0.5" thick) around the crumpled newspaper (figure 2). These pieces will ultimately become the torsos of the figures in the group model. For now, however, simply prepare them, and set them aside. Next, use your hands to mold four cylindrical shapes of clay around the newspaper for the figures' legs. Set all of the pieces aside and let them consolidate for 5-6 hours, or overnight (figure 3).

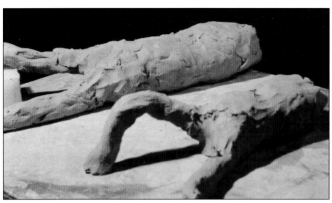

figure 3

Once the pieces have hardened (preferably overnight), unite them by simply pushing them together or using some pasty terra-cotta to "glue" them together. Then place the piece on a working wooden base. (Practically any type or size of wood will suffice.) To erect the piece on the base, place some wet terra-cotta on the base, and mount your model directly on top of it (figure 4). You may need to prop up the clay to support the figure; almost any sturdy objects—for example, screwdrivers, spoons, sticks, etc.—can be used for support, but they should be small enough so they do not to interfere with your modeling (figure 5.)

Once the basic shape of the figure is molded and supported, let it stand on its own for a day or two before beginning to work on it again.

Important: Do not remove the supporting materials once you begin modeling.

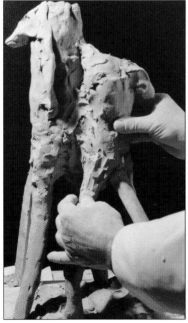

figure 4

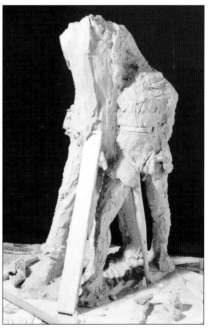

figure 5

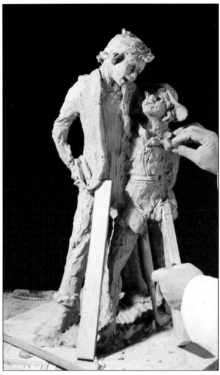

figure 6

Once you begin modeling the piece, you will need to dampen it with water periodically to keep it soft. Use your tools and fingers to shape and reshape the terra-cotta until you are satisfied with it (figures 6 and 7). If you need to add material to the piece, use pasty terra-cotta to help it adhere. (Remember that the supporting materials must not be removed.).

When you wish to stop working for the day, simply cover the piece with cellophane until you are ready to continue (figure 8). Keep in mind that it is always necessary to dampen the piece before resuming work; if you don't, the clay will be too hard to mold.

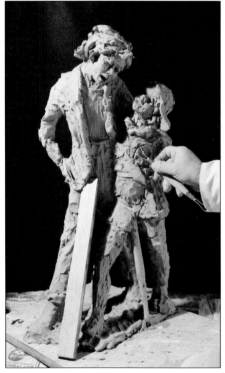

figure 7

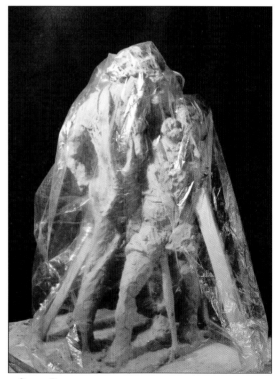

figure 8

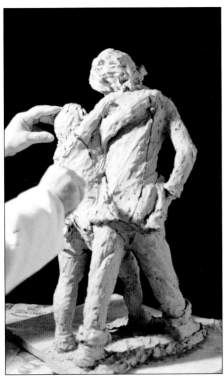

figure 9

Once you are completely satisfied with the model, you are ready to begin the most difficult phase of the procedure—removing the newspaper from the inside of the model and thinning out the clay. To facilitate the cutting procedure, it is important that the terra-cotta be well consolidated, but not too dry as to impede the procedure. The most important thing to remember at this stage is to proceed slowly, using the precision of a surgeon, regardless of how long it takes.

Use a small spatula to cut out a relatively large rectangular piece of clay from the back of each of the figures, as shown in figures 9 and 10. (Be sure to save the rectangular pieces of clay for later use.) Then, without removing the supporting materials, carefully extract the paper from inside the torsos (figure 11).

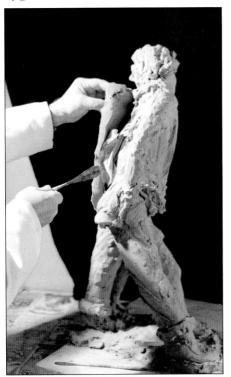

figure 10

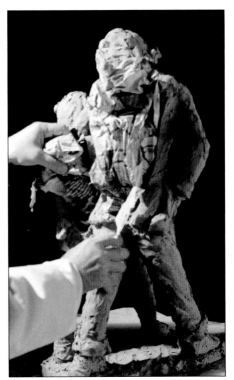

figure 11

Use the spatula to remove as much clay as necessary from the inside of the torso to produce a relatively uniform thickness (figure 12).

Figure 13 shows the hollow model (notice the extra clay that was removed to produce the required uniform thickness).

Now close the openings in the backs of the figures. First soften some terra-cotta by mixing it with water (refer to the discussion of this process on page 40). Then use the paste as a "glue" to reconnect the clay pieces that were cut away to remove the newspaper (figure 14).

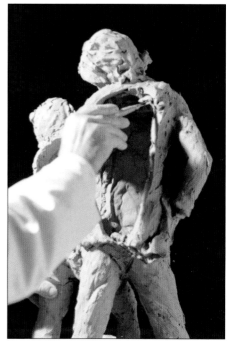

figure 12

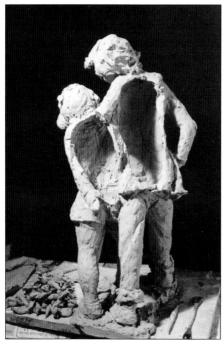

figure 13

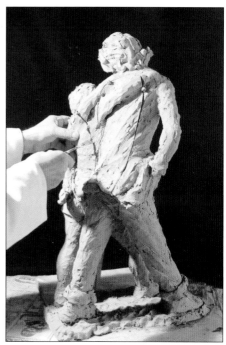

figure 14

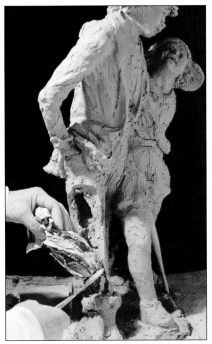

figure 15

Next, cut out sections of the figures' legs and heads, and *carefully* remove the newspaper (figures 15 and 16). Be sure that you remove all of the newspaper from both figures.

Now use some pasty terra-cotta to reattach the clay pieces that were cut away when you removed the newspaper (figures 17). Use your fingers to smooth and mold the clay, obliterating the seams.

Note: This is not an easy process, and it may require quite a bit of patience. For your first attempt, simply do your best and be content in knowing that you will improve with continued experience. By exercising care and patience, you will be surprised at how well you do.

figure 16

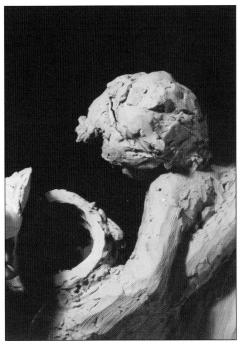

figure 17

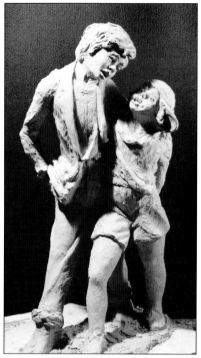

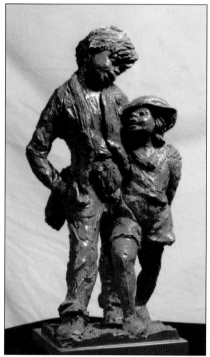

figure 18 *figure 19*

Apply any necessary finishing touches—for example, if some of the details were damaged during the hollowing process, you will need to retouch them. Then carefully remove the supporting materials from the piece (figure 18), and allow the model to dry for three to four weeks. Once it is thoroughly dry, you need to bake it in a kiln at 2185-2265°f for approximately 8-10 hours. If you do not have a kiln at your disposal, ask your local art dealer for details concerning the use or purchase of one.

Once the piece has been fired, it is ready for the patina (refer to pages 57 through 61).

Figure 19 shows the finished piece, a group I call *My Friend*.

The Patina

The patina—the final staining applied to statues—is a very important element in sculpture, and it is important to note that there are two basic types of patina: "fired" and "cold." Fired patina is the type usually applied to bronze statues by foundries using commercial chemical techniques. In contrast, cold patina is the most common process by which professional artists stain their finished pieces in their own studios using materials available in art stores. In both cases, preparing and applying the patina is a relatively complicated process. For example, regarding the "fired" variety, which is applied to bronze as well as other fused materials, many foundries have their own specialist who uses many chemicals (including ammonium chloride, ferric nitrate, ammonium sulfide, silver nitrate, sulfurated potash and others) which are mixed together in various proportions and applied by flame directly onto the sculpture to produce the desired patina. Ironically, in many cases the artists themselves are not totally satisfied with this "technical" method.

Many artists actually produce their own patinas of the "cold" variety, preferring this method over the one described above, especially for their original pieces. They usually experiment by mixing a host of natural and synthetic colors, as well as other materials, such as minced flowers, burned motor oil, vinegar, milk, alcohol, ammonia, sea water, and even wine. This experimental stage takes years of study to achieve, and when the artist is finally satisfied with a certain patina, he or she will usually store a generous portion of it in a refrigerator for later use. Some artists become so adept at mixing patina potions that they can make a new statue look as if it is thousands of years old.

On the following pages I will demonstrate two common types of cold patina that can be applied on terra-cotta: a bronze patina and a colored patina.

The Bronze Patina

The objective when making a bronze patina is to *stain* the terra-cotta model in such a way that it looks like a bronze sculpture. To do this, you will need to purchase acrylic paints (see Step 3 below), a tube of gold leaf paste, a can of terra-cotta colored spray paint, and some orange shellac (all available at art supply stores).

Note: Terra-cotta comes in many colors. For this exercise it is important to select the type that is whitish-ivory after it has been fired.

Step 1: Use a paint brush to apply a coat of orange shellac to the figure; allow it to dry thoroughly (figure 1).

Step 2: Apply a coat of terra-cotta-colored spray paint and allow to dry. Apply a second coat, making sure that the details of the statue are completely covered (figure 2). Let dry.

Step 3: In a small bowl or jar, mix the following **acrylic paints** to simulate the color of aged bronze: 4 parts pthalo green, 2 parts Prussian blue, and 1 part lamp black. Then dilute the color mixture by *slowly* adding water, creating a liquid consistency. The water allows the color to flow easily onto the sculpture. (Approximately 10 to 12 ounces of water should be enough for a sculpture this size.) Make sure that you are satisfied with the color mixture, and then use a paint brush to coat the entire statue (figure 3). Let dry, and then apply a second coat, making sure that the small details and crevices are covered.

Step 4: Wet the paint brush with the bronze mixture again, but this time brush the mixture into the previous coating. Continue brushing until the piece is virtually dry. If some areas appear too light, repeat the process (figure 4) until you are satisfied. Then allow the piece to dry thoroughly.

Step 5: When the piece is completely dry, take a small portion of gold leaf paste and, using a clean brush, apply a very light coat to the protruding areas of the statue—for example, the facial features and other extremities. Be careful when applying the gold leaf; the more you use, the brighter the piece will be. It is best to start out with a small portion and add more until satisfied (figure 5).

Step 6: Once the gold leaf is dry (15-20 minutes), you may want to apply a spray coating of clear varnish over the entire piece to protect the color. This clear coating will protect the patina, but it will not change the color or appearance of your finished product. The patina is now complete (figure 6).

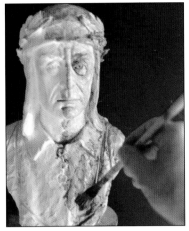

figure 1

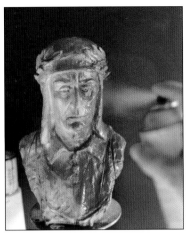

figure 2

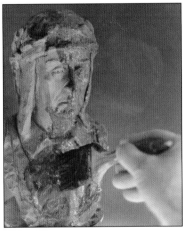

figure 3

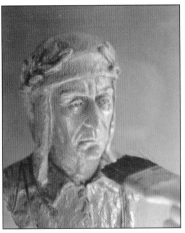

figure 4

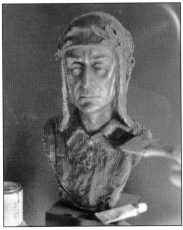

figure 5

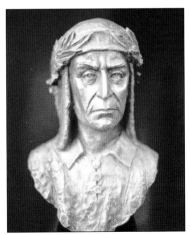

figure 6

The Color Patina

The color patina is used to actually *paint* the statue as opposed to staining it, as you did in the previous example. Here you can use various colors to actually give your piece a realistic appearance.

To produce a color patina, you must use **acrylic paints**. These are available in any art store and, of course, the exact colors needed will depend on your taste. The following are step-by-step instructions for creating and applying a color patina to a finished model.

Step 1: After firing the piece (and allowing it to cool), use a paint brush to apply a coat of orange shellac over the entire piece (figure 1). Allow it to dry for 3 to 4 hours.

Step 2: No matter what color terra-cotta clay you used, cover the entire piece with a coat of terra-cotta or brown colored spray paint and let dry for 2 to 3 hours.

Step 3: Once the terra-cotta paint is dry, paint the figures with the desired colors. Be sure to let each application of color dry before applying the next (figure 2). Acrylics are simple water-based colors, and you may select whichever brand you prefer.

I will not attempt to dictate to you which colors to use because I believe that the true talent of any given artist (or would-be artist) partly depends on his or her own creativity in the use of colors.

Step 4: Continue applying the various colors. It is not necessary to follow any particular order or color at this stage. I have chosen to use the ones shown in the accompanying figures, but, of course, you can use whatever colors you like. The only important thing to remember is to let one color dry thoroughly before applying the next (figure 3). This process may take one or two days, but it is absolutely imperative that you allow the piece to dry thoroughly before proceeding.

Step 5: Once you have completed the work, it is best to let it dry for a day before you apply a final protective coating of clear varnish spray to the entire piece to help preserve the colors. The color patina is now complete (figure 4).

I titled this piece *Teachers and Students*.

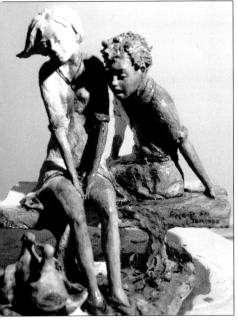

figure 1

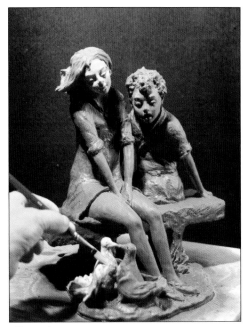

figure 2

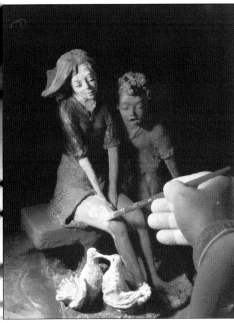

figure 3

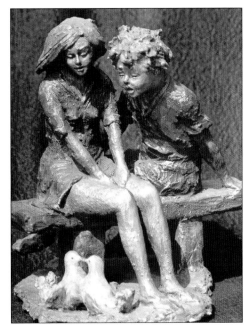

figure 4

Gallery

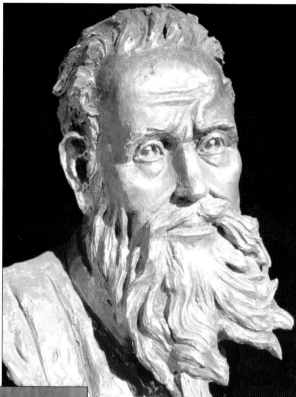

The two pieces shown here were produced using the three-piece stampo method demonstrated on pages 42-48. Both of these pieces were produced in limited editions.

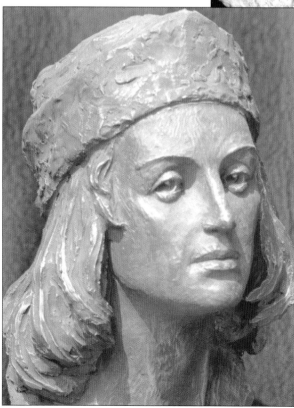

(top right)
Michelangelo Buonarroti
(1475-1564)

(bottom left)
Raffaello Sanzio (1483-1520),
The Divine Painter

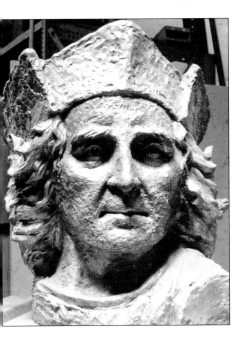

These original portraits were executed with the hollow terra-cotta method demonstrated on pages 35-41

(top left)
This bronze bust of Christopher Columbus is almost three times life-size and demonstrates the limit that can be reached using *The Little Champion* method discussed earlier. This work is on permanent display at the Bowers Museum in Santa Ana, California.

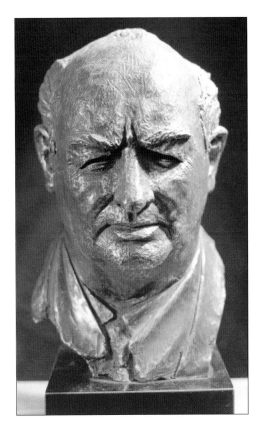

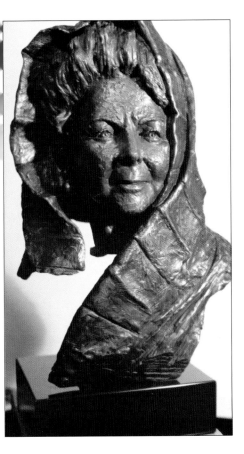

(above right)
This is a life-size bust of M.S. Gorbachev, former president of the Soviet Union.

(bottom left)
This is a bronze of the famous soprano G. Simionato. It is one and a half times life-size and is on permanent display in the Metropolitan Opera House, Founder's Hall at Lincoln Center in New York City.

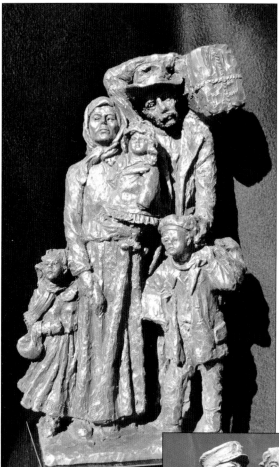

This group sculpture, titled *The Immigrants*, was completed utilizing the semi-hollow terra-cotta method illustrated on pages 50-56.

This group is similar to the one above, but it is composed of seven elements. Execution of this type of work is quite ambitious because of the number of elements. Experience and practice are mandatory requirements for this type of undertaking.

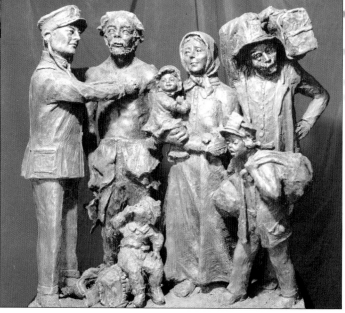